IMAGES
of America
SHASTA COUNTY

Redding's Old City Hall still stands at the corner of Market and Shasta Streets, but its role has changed significantly since it was built in 1907. It housed the city offices, city council, and police department until 1979. The red brick building was restored in 1987 and is now used as an art gallery and theater.

IMAGES
*of America*

# SHASTA COUNTY

Shasta Historical Society

ARCADIA

Copyright © 2003 by Shasta Historical Society.
ISBN 0-7385-2854-4

First Printed 2003.
Reprinted 2004.

Published by Arcadia Publishing,
an imprint of Tempus Publishing, Inc.
Charleston SC, Chicago, Portsmouth NH,
San Francisco

Printed in Great Britain.

Library of Congress Catalog Card Number: 2003109387

For all general information contact Arcadia Publishing at:
Telephone 843-853-2070
Fax 843-853-0044
E-Mail sales@arcadiapublishing.com
For customer service and orders:
Toll-Free 1-888-313-2665

Visit us on the internet at http://www.arcadiapublishing.com

City Hotel was located at the corner of Market and Tehama Streets. The two men pictured in chef attire in the center are Mr. Edovach (left) and George Burdick.

# Contents

| | | |
|---|---|---|
| Acknowledgments | | 6 |
| Introduction | | 7 |
| 1. | Indigenous People and Early Settlers | 9 |
| 2. | Mining and the Town of Old Shasta | 23 |
| 3. | Logging of the Big Trees | 41 |
| 4. | The Town of Redding | 53 |
| 5. | Other Areas and Communities | 105 |

# Acknowledgments

This book was begun in 1930 when the founders of the Shasta Historical Society realized that the stories and artifacts of its pioneers were soon going to disappear from local history. Thanks to the efforts of far-seeing volunteers, such as Jean Moores Beauchamp and Marlys Barbosa, over 12,000 photographs have been archived, copied, and, with a generous donation from the Leah F. McConnell Trust, preserved in electronic format.

The goal of the society and its volunteers is to collect, copy, and make these historical photographs available to the public. Because of the community's effort, their donations and loans, some of our favorite photographs are presented to you in book form here.

A new generation of volunteers is working to save the images that continue to be donated. Our volunteers arrive on a regular schedule to work on projects that they truly love—archiving the photographs and history of Shasta County to make them available for future generations.

We would like to thank the many people, past and present, who have made this wonderful book possible. Present-day volunteers include Pat Ferreira, Betty McKean, Lola Louthan, Marie Carr-Fitzgerald, Coral Caldwell, Evelyn Hoppes, Elsie Zanni, Bonnie Proebstel, Susanna Luzier, Kathryn Raymond, and Larry Watters. A very large thank you goes out to Dr. Al Rocca for his encouragement. We are grateful, too, for his offer to write the introduction for the book and each chapter.

To see images of these people and events captured for that split second, some from over 100 years ago, is truly a miracle, and we are pleased to have the opportunity to share our good fortune with you.

Diane Kathleen
Shasta Historical Society Office Manager

These eastern Shasta County volunteers participate in the Red Cross's nurses training, c. 1915.

# Introduction

*Al M. Rocca*

This history of Shasta County is founded on the confrontation between a rugged and uncompromising environment and a courageous and determined people. The diverse geography extends from the floor of California's great Central Valley and rises through the eastern and western foothills all the way to the top of majestic Mount Lassen. The resulting climate adds to the physical challenges of prospective settlers by presenting extreme heat in the summer months and lots of snow and rain in the winter season.

Our courageous native populations bound themselves into thriving tribal communities. The Wintu and Yana, largest of the tribal groups, prospered despite the harsh summer and winter conditions. Generation after generation of Native Americans fished, hunted, and collected seeds and berries before the incursion of whites in the 19th century. Colorful marriage ceremonies and feasts for special occasions provided a foundation for a rich cultural tradition. Little did they know that dramatic changes would soon be unleashed on them and the local environment.

Jedediah Strong Smith, one of America's earliest mountain men to trek across the country, was the first white man to set foot in Shasta County. Shortly after his visit in 1828, other trappers and mountain men crisscrossed isolated valleys and mountain passes. In 1837 Ewing Young drove the first cattle along the California Trail; later numerous settlers traveled through the area. One of them, Pierson Barton Reading, appreciated the natural beauty of the river bottomlands and the surrounding mountains and petitioned the Mexican government for the right to settle permanently. His rancho, which he named Rancho Buenaventura, stretched for miles along both sides of the Sacramento River.

Reading remained the only white settler until the Gold Rush of 1848–1849. Shasta County became the "Gateway to the Northern Gold Rush," and hundreds, then thousands, of eager miners poured into the valleys and foothills. Quick-rising boomtowns soon dotted the major creeks feeding into the Sacramento River. Horsetown, Jackass Flat, and Whiskeytown were a few of the wild, wide-open mining towns where bachelors worked long tedious hours panning for gold nuggets. Few of these young, energetic dreamers became rich, but many of them decided to stay in the area and seek other means of employment.

One of the early boomtowns, Shasta, survived the decline of the Gold Rush and went on to become the regional business center for Shasta, Trinity, and Lassen Counties. Pioneers who did strike it rich, like Karl Grotefend, used their profits to start hotels, restaurants, and dry goods stores in the town of Shasta. Grotefend and a partner opened the St. Charles Hotel and later a store. Fires were always a problem, as the majority of buildings that went up were constructed of wood. One particular fire in 1853 wiped out many of the businesses in the "Queen City." Resilient residents quickly cleared away the burned remains and constructed new buildings. Through the 1860s, die-hard gold seekers continued to come to Shasta, stock up on mining supplies, and head for the creeks. By this time the impact of white settlement on the Native American culture was having a disastrous impact. Disease ranked as the main culprit in eliminating native peoples, yet incidents of violence by whites against the local tribes became more and more accepted.

During the 1870s a diversified economy began to emerge. Farming in the southern part of the

county centered on the new town of Anderson. Meanwhile, Livingston Stone, having arrived from the East Coast and dreaming of opening several fish hatcheries, convinced federal officials that a profit could be made on selling salmon fish eggs. His first hatchery in the McCloud River area proved successful and led to the opening of another larger facility at Baird.

The major event of the 1870s was the news that the railroad, the Central Pacific, would be coming through Shasta County. Business leaders in the town of Shasta expected the route to move through their town, yet to their dismay they learned that railroad engineers decided instead to create a railhead three miles short of the "Queen City." The Central Pacific officials named the town Redding, to honor their boss, Benjamin Bernard Redding, the general land agent for the railroad company.

Within months of laying out of the new town, everyone in the town of Shasta and those living in the nearby valley communities realized that future prosperity depended on access to the railroad depots at Anderson and Redding. One by one, settlers moved near or into Redding. This was especially true of business owners in Shasta. Chauncy Carroll Bush was among the first to understand the need to move his business, and he became the first to open a mercantile store in the new town. Brick hotels, mercantile stores, saloons, and churches formed the core of Redding with tidy, wood-planked residences lining rectangular city lots. The town grew quickly and became the county seat in 1887.

As the decades moved on, the towns of Redding and Anderson grew along with unincorporated communities such as Shingletown, Cottonwood, Whitmore, Burney, Palo Cedro, and Bella Vista. Economic prosperity rose with the exploitation of the area's natural resources such as copper and timber. With the completion of Shasta Dam in 1945 and routing of Interstate 5 through the county in the 1960s, prosperity was permanently assured.

The history of Redding and Shasta County is an exciting story to tell, and its best storyteller—as well as a highly respected local historian—was the Honorable Richard B. Eaton. His recent death is a huge loss to the many hundreds, even thousands of friends and students who came to know and love him. He had deep roots in the county's history. Judge Eaton's grandfather, Charles Behrens, served as the county sheriff for a number of years beginning in 1889. His mother was the county treasurer through most the 1920s and 1930s. Eaton was educated at Stanford University, served in the army during World War II, and returned to Shasta County to eventually open a law office and serve as a superior court judge for 25 years. He enjoyed researching, reading, and talking about the history of early county residents. Eaton became an active member of the Shasta Historical Society, where he continually offered his expertise and leadership. He will best be remembered for the engaging lectures on local history that he gave in numerous schools and community venues, and for his warm, open friendship.

The Honorable Richard B. Eaton was born on December 22, 1914 and died on July 29, 2003.

# One
# INDIGENOUS PEOPLE AND EARLY SETTLERS

Historians have estimated that California—before white exploration and settlement—was home to around 100,000 Native Americans, a larger population than any other region of the United States. Within this state a diverse collection of tribes prospered, enjoying a relatively mild climate and ample food sources. In Shasta County the major tribes, with a population of several thousand, were more or less separated by physical barriers, such as mountains and rivers. In the Sacramento River Valley and surrounding foothill areas of the western portion of the county, the Wintu Indians thrived in large numbers. Immediately to the east, the Yana Indians spread out in small tribes from the foothills to the upper elevations of the Cascade Mountains. The Yana and Wintu Indians and other small tribal groups, such as the Achomawi and the Atsugewi, found abundant game, fish, and plant foods to sustain a healthy lifestyle.

Through the 1830s and early 1840s trappers and adventurers hiked through the county. One of these early pioneers, Pierson Barton Reading, petitioned and received permission from the Mexican government to acquire extensive land holdings in the county along both sides of the Sacramento River.

Dressed in a combination of their native and European-style clothing, six Wintu men stand on the bank of the Sacramento River at Diestlehorst Flat.

Native American women were often enlisted to perform domestic chores. This *c.* 1859 tintype depicts one of Pierson B. Reading's twin sons and his Wintu nurse.

Archival information indicates that this *c.* 1851 tintype of Kate Luckie was taken before the Indians at Old Shasta were moved to the Round Valley Reservation in Mendocino County in 1859.

This c. 1900 photograph shows several Round Mountain Indian baskets. Such baskets, used for gathering, cooking, and storage, were made from assorted materials, including hazelwood branches, skunkbush twigs, and poison oak stems.

Mothers taught their young daughters how to gather berries and acorns. Acorn meal was formed into flat breads that could be eaten as is, or as a tortilla that could be filled with meat or berries.

Chief Col-choo-loo-loo, pictured here c. 1880, saved the life of his friend Livingston Stone when other Wintu leaders wanted to drive him and his men away. Stone was the superintendent of the Baird Fish Hatchery.

This c. 1910 image shows Samson, a Wintu caught between two cultures. He and his family lived in the Slate Creek area north of Lake Shasta. Samson once packed a 190-pound anvil from Delta, near Lakehead, to the mines in Trinity County, and at age 70, he could outrun all challengers.

When the stage came through Schilling (Whiskeytown) in 1877, these three ladies had their photograph taken by a man charging 25¢ for a photo. From left to right are Mrs. George Dicks (Dix), Mrs. W.E. Anderson, and Mrs. Charlie Morton.

Kate and Lizzie B. Robert, pictured c. 1904, were the last two known full-blooded Yana women. The people of the Yana tribe were known to be fierce and independent; their warlike reputation may have been due to the resistance offered to white settlers by one or two of their bands.

This 1930 photograph shows Samson Grant, a member of the Hat Creek (Atsugewi) tribe, in full dress armor. Because of the mountainous territory in which they lived, this tribe was spared contact with whites until relatively late. In 1859 General Kibbe began capturing, killing, and destroying their villages and food supplies. Those that surrendered were taken to the Round Valley Reservation.

This photograph of an Atsugewi couple named Brown was taken in 1870 at Deer Flat on a gathering and hunting expedition. In this culture, women were considered more valuable than men because of their food-gathering abilities. When enough food had been collected, the tribal chief would call for a celebration called "Big Time."

Eighty-year-old Sarah (Num Ken Chata) Green was a Wintu Indian who lived in Whiskeytown. She is pictured here in August 1929 with her dog Pompey, a hawk feather, rattlesnake necklace, shell beads, and a buzzard feather fan.

Native Americans used canoes on the Sacramento, McCloud, and Pit Rivers. Dugout canoes were usually made of pine or cedar.

The Achomawi (Pit River Group) Indians inhabited the entire northeast corner of Shasta County. They were named for the pits dug by the women on the trails beside the river to capture deer and bear, as well as enemies. Pits were dug and sharpened antlers or spears were embedded in the bottom to impale whatever fell in.

Olsen Ranch petroglyphs on Stillwater Creek are probably the largest and most varied of any in Northern California. These ancient petroglyphs have been added to the National Register of Historic places for protection and preservation.

Many of the early settlers married local Indian women. Julia and Millie Elmore are the children of the union between Waldo Elmore and Lucinda Alpom, the daughter of Chief Num-te-ra-re-man of the Wintu. (Courtesy of Allen Friebel.)

Waldo Elmore, a miner all his life, taught school in Copley in the 1890s and early 1900s. Standing in front of him are his daughters, Julia (left) and Narcissus. Seated third from the right is Jenny Houseman, his granddaughter. (Courtesy of Allen Friebel.)

Dr. George Silverthorn, a native of England, married a Wintu woman named Lucy. Three of their four children are pictured here, from left to right: Tilly, Mary, and William Silverthorn.

Located on the Pit River, just below Copper City, the Silverthorn Ferry was operated by Dr. George Silverthorn. Ferries were held in position by a cable across the river and were propelled by pointing one end upstream with the force of the current striking the ferry at an angle, forcing it across the river. This ferry operated from 1853 until it was auctioned off by the board of supervisors in 1944.

*Old Style Hat Creek Indian Fish Trap HW-1926.*

Used by the Hat Creek Indians, this fish trap had a loose weave to let water flow easily through while keeping the fish trapped. The trap could be left in the water or trolled slowly. Salmon were plentiful from May to October; however, other fish could be caught most of the year.

A Karok Indian uses a handmade net and fishes from the rocks at My-kee-arra on the Klamath River.

Established in 1872, the Baird U.S. Fish Hatchery was located on the McCloud River approximately 18 miles north of Redding. The building on the left is where the salmon eggs were hatched. The fish were then sent by wagon, railroad, and ship to various locations throughout the United States. Some salmon became established as far away as New Zealand. (Courtesy of Ralph Hollibaugh.)

This photograph was taken on the McCloud River near Baird Hatchery, and the hatchery buildings are visible in the background. Native Americans dried fish on elevated racks, pounded them into salmon flour, and stored it for the winter. (Courtesy of Ralph Hollibaugh.)

The Wintu at Baird were called Winemem, meaning "middle-water." When they heard of the contemplated hatchery, they feared a loss of their fishing grounds. The Wintu were given as much salmon as they wanted after the fish were stripped of eggs and sperm.

Joe Bender was a Wintu man who worked as a handyman at the Vollmers Summer Resort. In this c. 1900 photograph, Joe boils sheets in a pot hung over a fire on a makeshift tripod. Vollmers was a stopping place up the canyon north of Redding and was popular with miners, cowboys, construction stiffs, and bored city slickers.

Buckskin Jack, chief of the Hat Creek Indians, died in March of 1921 at the age of 100 years.

The Maidu Indians made their homes from wooden planks. Each house consisted of a scooped out circular depression. A pole was secured in the middle of the depression; other poles were tied to it and covered with bark or evergreen boughs.

# Two
# Mining and the Town of Old Shasta

News spread quickly in all directions once James Marshall's discovery of gold in the American River was announced to his boss John Sutter. When Pierson B. Reading heard the news, he saddled his fastest horse and made haste for Sutter's Fort in Sacramento. Sutter escorted Reading to the gold site Coloma, where Reading calculated that the terrain and river deposits were similar to the Shasta area. Upon his return to his rancho home at Balls Ferry, he rounded up some of his Wintu workers and headed for upper Clear Creek. Standing in ankle-deep cold water Reading and his miners panned thousands of dollars worth of gold flakes and nuggets.

A huge horseshoe-shaped zone of gold mining boomtowns and diggings arched from the Trinity Alps in the west and extended up to the mountainous region around Mount Shasta and back down to the foothills of Lassen County. Reading witnessed thousands of newly arrived miners swarming over his rancho on their way to remote creeks. The Irish came; so did the Germans, Italians, and Chinese.

Tent towns sprang up by the score. One of the first was Horsetown, near Reading's original gold site on Clear Creek. Dominated exclusively by men, life in these towns was crude and monotonous. The arduous task of panning or manning a Long Tom sluice box provided hard work that never appeared to pay off. Women were a novelty. Magazines or old newspapers with pictures of women brought a handsome price.

Taking center stage as the "Gateway to the Northern Gold Rush" was the town of Old Shasta. Originally known as Reading Springs, the tiny enclave of tents and wooden buildings mushroomed in 1849.

Shasta County pioneer George Grotefend poses with two companions in this 1880s photograph. Extended trips into the hills and valleys of the county called for a sturdy mule and lots of supplies. Wide-brimmed hats became popular as a means of blocking the searing Shasta summer sun.

In 1848 Major Pierson B. Reading made the second-largest gold discovery in California in Clear Creek at the place now known as Reading's Bar. He worked the deposits with a large group of Native American laborers. The gold was then transported to Sutter's Fort and exchanged for coin and merchandise.

Built in 1847, the Reading Adobe was the first American dwelling in Shasta County and the first seat of Shasta County. It was built on the Mexican land grant Rancho Buena Ventura that had been issued to Pierson B. Reading. Ranch work was performed by Wintu Indians who lived on the rancho.

24

Chinese immigrants appeared in Shasta County during the Gold Rush in the early 1850s. Serious racial problems developed, leading the California legislature to pass a law in 1858 prohibiting further Chinese immigration into the state. Redding's Chinatown mysteriously burned to the ground in 1886 and Chinese residents were expelled from Shasta County.

Two miners take a break beside a Long Tom sluice box at the Washington Mine, two miles northwest of French Gulch, in this mid-1800s photograph. The mine, discovered in 1852, was one of the earliest lode mines in California, and its rich ore yielded as much as $600 worth of gold per ton.

A dog accompanies a stage coach as it travels Upper Main Street in Shasta in this c. 1870 photograph with freight wagons in the background. The streets are wide, a decision caused by fires years before, and unpaved.

Masonic Hall and the adjacent Armory in Shasta are pictured here. Western Star Lodge No. 2 is the oldest chartered lodge in California. Chartered in Missouri in 1848 and brought to California by Saschel Woods on Peter Lassen's wagon train, it is still in use today.

The whole town would turn out to hear the Shasta Band play at local functions including the Fourth of July, May Day, and parades.

First settled in 1848 by gold miners from Oregon, Old Shasta was originally called Reading's Springs and it served as a distribution point and commercial center for surrounding areas. The town was an important place until the railroad arrived in 1872 and bypassed Shasta for the town of Redding.

27

Here, mules pack hydraulic pipe to the Nash Mine in Trinity County in the early 1900s. The pipe supplied constant high-pressure water to the water cannons called "Little Giant." Hydraulic mining caused a great amount of damage to rivers, streams, and agricultural lands. The Anti-Debris Act of 1883 shut down the larger operations.

Two men add weight as they guide the nozzle of a "Monitor" water cannon at the La Grange Mine west of Weaverville. At the peak of production, from 1909 to 1915, this was the largest hydraulic gold mine in the world and about $8 million worth of gold was extracted from it.

The Keswick Hotel, owned by Dan McCarthy, was 70 feet by 108 feet long and boasted 35 rooms. The town hall and the town offices were housed on the hotel's second floor. The town of Keswick was named for the Mountain Copper Company's president Lord William Keswick. Mining operations began in 1896.

This c. 1888 view shows the first hotel and store of Bernhard Golinsky in the town of Kennett. Seated, from left to right, are Bernhard, his wife Rosa, his nieces Martha and Henrietta, and his nephew Jake, who later became the community's postmaster. The town now lies beneath the waters of Shasta Lake.

29

Freight trains of four horses, but sometimes six, eight, or more, moved supplies from either Redding or Red Bluff to Harrison Gulch. They hauled timber and wood to be used on construction and for the furnaces to generate electricity. (Courtesy of Ralph Hollibaugh.)

Located in the southwestern corner of Shasta County, the narrow Harrison Gulch, pictured here c. 1900, was named for William Harrison, the first judge of Shasta County. He was elected in 1850. The Midas Mine, Victory, and the Gold Hill mines were booming. (Courtesy of Ralph Hollibaugh.)

A gold miner with his packed donkey had this photograph taken in 1870 by the photographer Middlemiss in front of his Redding studio.

Located at 1449 Market Street in Redding, the Weldon and Dittmar Assay Office is pictured here c. 1915. Besides having an assay and drafting business, Hal Weldon and M.E. Dittmar also produced a monthly mining journal called *Mineral Wealth*. Weldon invented a simple process for assaying gold and silver ore, using a solution that sold for $1 a bottle.

Discovered in 1894, the Midas Gold Mine was located in Harrison Gulch. Four million dollars was taken out of the mine by 1939. These miners wear candles on their hats and are covered with candle wax.

The Mammoth Copper Mine was located four miles up the mountain from the town of Kennett. At one time, 2,300 men were on the payroll, and many deaths occurred at the mine from cave-ins and dynamite blasts. This rescue crew was photographed c. 1914.

At the Mammoth Copper Mine ore cars traveled five miles underground at the 500-foot level. The mine produced 264 million pounds of copper during its period of operation.

During the 20 years the mines and smelter operated, they yielded the greatest portion of the $110 million worth of copper ore produced within the boundaries of Shasta County. Pictured here is the Mammoth Mine's smelter furnace.

Two young girls compete in a footrace at Mammoth Copper Mine on July 4, 1914. The mine was near the community of Kennett, a railroad town founded in 1884.

The Fourth of July, this one in 1914, was always a big event at the Mammoth Mine. Houses were decorated with bunting and flags, and at 4 a.m., the celebration began with a case of dynamite going off at the mine dump. The day was filled with games and races, a picnic was held on Little Backbone Creek, and miners would hold rock-drilling contests, races, wrestling matches, and a mucking contest.

This 1886 photograph shows employees cleaning strawberries at the Delamar Hotel. Rich in gold, silver, and copper, the mining town was named for Captain J.R. DeLaMar, who built the smelter for the Bully Hill Mine in 1899.

Chicago Mine was established in 1866 by Noah and J.B. Batcheler, who mined gold and silver using a five-stamp mill. This 1910 view shows an ore cart at the Chicago Mine.

This is a rare outdoor ambrotype of the Swain cottage and flume on Whiskey Creek near the town of Old Shasta. Alexander Swain came to Shasta County in 1855. He was a miner until the mines played out, and he then became a steward of the county hospital.

Snow surrounds a bunkhouse at the Mammoth Copper Mine in this c. 1916 photograph. The mine, in the hills west of Lake Shasta above Kennett, was one of the biggest copper mines in the world. Wages ranged from $2.60 to $2.75 per day.

This photograph depicts the building of the Mountain Pride Dredge in 1898. Dredging brought up the deep gold-bearing gravels and turned the land over, leaving the rock piles (tailings) that are still visible today.

The first dredger in Shasta County was built by John and Charles Diestelhorst in approximately 1895. It operated on Middle Creek near the mouth of the Sacramento River.

An unknown couple sits on the 1,000-foot-high mountain of quartz rock at the Quartz Hill Mine, c. 1902. The quartz was used as flux at the Keswick smelter.

A group of miners and their families pose at the mouth of the Quartz Hill Mine, c. 1902. Tunnels were dug into the mountainside to get to the gold-bearing quartz inside.

Pictured here, c. 1910, are ore bunkers at Cuargo, a railroad spur just north of the town of Keswick.

Messrs. Jones, Sandkuhlm, Cunnison, and Roach keep one another warm at the Mammoth Mine c. 1900, where the snow could get more than six feet deep. The St. Bernard, named Nero, in the photograph, weighed 175 pounds and pulled sleds.

39

Coram, the copper smelter for Balaklala Mine, was on the west side the Sacramento River below the future site of Shasta Dam. On the July 14, 1913, the Coram smelter stack was blown.

This c. 1910 photograph shows a wooden footbridge extending across Backbone Creek with the Kennett copper smelter in the background. The smelter and Kennett came to an end in 1930 and both now lie under the waters of Shasta Lake.

# Three
# LOGGING OF THE BIG TREES

Large-scale logging in Shasta County is synonymous with the earliest white settlement, which began with the Gold Rush in 1848. The hundreds of arriving miners needed lumber for building cabins, Long Toms, rockers, and flumes. Enterprising loggers saw the wealth of quality timber in the eastern foothills, especially in and around the Shingletown area, and sawmills sprang up in a number of locations. These men worked hard to haul the cut trees to the Sacramento River where the timber was floated downstream to processing mills further south. The thirst for lumber continued into the 1860s as Northern California's population exploded.

Lumber companies opened in Shasta County and the rush was on to get bigger trees at higher elevations. An extensive series of huge, wooden flumes ran downhill for miles to "river corrals" where lumber was sorted and prepared for shipment to processing mills. The lumber boom continued in the 20th century, with new sawmills appearing north of Redding.

In the days before trailers were developed, big wheels were used to haul large logs out of the woods. Four-horse teams were used to skid the logs to landings. The 12-foot iron wheels were used in areas that were relatively flat. The early big wheels had no brakes and were very dangerous to both men and horses. Redding Iron Works developed a "slip tongue" to fix the braking problem. This photograph was taken near Darrah Springs in the early 1900s.

Jeff Reed and John Hansel make an undercut in this photograph. Trees were cut down by two men pulling a crosscut saw. An undercut was made on the side to which the tree would fall, a back cut was made, and wedges were placed in the cut to keep the saw from binding. Oil was sprinkled onto the saw to help it cut through the pitch. When the tree snapped, the saw was quickly withdrawn and the shout of "timber" would ring out.

These 1910 loggers appear with tools of their trade—big wheels, whip saw, ax, and peavy. Hardworking loggers labored in steep terrain to cut trees, hook them up to donkey engines, and haul them to a site where they were loaded onto narrow-gauge rail cars or placed in a fast-rushing flume to be sent downhill for processing at the sawmill.

Five unknown men stand beside a fir log with a sawing machine hooked to the log. Many attempts were made before power finally replaced brawn in tree falling. In 1879, a steam-powered tree faller was demonstrated. A gasoline model, with a water-cooled motor, appeared in 1905.

In 1881, John Dolbeer, a Eureka logger, invented a steam donkey engine, a piece of equipment that made a tremendous impact on logging methods. Unlike most labor-saving devices, it actually created jobs. Three men, a boy, and a horse were necessary at the machine. Others were kept busy cutting firewood. This photograph was taken in 1910.

*Lumbering in Early Days.*

In the early days, oxen were the first to be used to haul logs. Horses, big wheels, traction engine, trains, flumes, and rivers were other means of moving logs.

Horses and mules used in logging were steered by men sitting on the wheel animal. The team was usually made up of 12 or 16 horses or mules.

This 1890s photograph depicts a steam-operated traction engine at Thatcher Mill. Steam tractors, for use in logging the woods, were developed in 1894. Both the Best Tractor Company and the Holt Manufacturing Company put models on the market that year.

An old Barney locomotive sits on an unusual log trestle at Terry Mill Railroad in Round Mountain. The construction of the narrow-gauge rail lines, some of which ran uphill for miles, was difficult; many lines constantly wound around hillsides and, in some cases, looped back to form dangerous hairpin curves.

This c. 1920 photograph shows the damage from a break at the Terry Mill Flume. Built by Joe Terry, the flume was completed in 1897. The scaffolding was of varying heights, reaching as high as 90 feet above the canyon.

Men work on the Terry Mill Flume a half mile north of Ingot. The flume was tended by a group of "flume-jacks" from Hatchet Mountain to the valley where Bella Vista once stood before being moved to Highway 299 a mile away. In 1920, the Red River Lumber Company succeeded the Terry Lumber Company in the ownership of the timberlands and flume.

LaMoine, located beside the Sacramento River at the mouth of Slate Creek, was first known as Slate Creek Stage Station. LaMoine Lumber and Trading Company operated one of the largest sawmills of the time from this town.

This 1902 photograph shows a traction engine pulling logs and people at Benton Mill in Shingletown. Shingletown was named for the many shingle-making camps in the area.

This group poses on a set of big wheels at the Terry blacksmith shop in early 1900s. J.E. Terry built a flume from the mill in Shingletown to Bella Vista where the lumber was processed and sent by rail to Anderson. The mill operated from 1872 to 1922.

Patrons gather at the bar in a saloon in the town of Bully Hill in this early 1900s photograph. The mirror behind the bar has "Happy New Year" written on it. Placer gold was discovered at Bully Hill in 1853.

Trees for the Turtle Bay Mill, built in 1896, were cut at Flat Woods near Montgomery Creek and skidded in greased chutes into the Pit River. It was not uncommon for two to three men to meet their death by drowning each season, but this method for driving logs was used until 1908. Included in this photograph are river rats Jim Carney, Frank Buick, Walter Chase, Joe Kaiser, and Dan McCloud.

Built by William Betts, the Benton Mill in Shingletown was powered by a Pelton water wheel. In 1895, Betts sold his interest in the mill to Hart Benton, who was one of the first sawmill men to own and operate a traction engine.

Inside Thatcher Mill, from left to right, are George Thatcher, William McKee, Lloyd Thatcher, H.W. Knapp, Thomas Thatcher, Henry Ringstorf, John Ringstorf, Arlo Tisdale, Ben Meineken, Marvin Dow, Alonzo Cleland, and Frenchie.

In this *c.* 1903 image, Martin Leach (left) and Levi Caldwell display 36-inch clear pine boards from the LaMoine Lumber and Trading Company's sawmill. The company, established in 1900 by the Coggins brothers, operated one of the largest sawmills at the time.

Dave Bjorn stands on a log footbridge with his dogs near the Forward Brothers sawmill near Manton in this c. 1910 photograph. The building in the background is the original mill built on Digger Creek in 1908.

The Forward Brothers Mill in the Manton area was operated by the same family from the time it was built in 1898 until it closed in the 1960s.

51

Ladies from Thatcher's Mill near Shingletown circle a Douglas fir not far from McCumber Lake in this c. 1900 photograph. Ezekial Thatcher built and operated one of the first sawmills in the Shingletown area in the days when oxen were used to draw the logs.

Standing around an improvised lunch table in the woods near Round Mountain are the Terry Mill hands. Jim Marshall is third from the right.

# Four
# THE TOWN OF REDDING

The railroad craze that swept across America in the mid- to late 19th century provided the spark for the planning of new communities in northern California. Following the natural topographic grade of the Sacramento River, Central Pacific Railroad engineers decided to lay out a railhead where the terrain began to rise and the river narrow. This spot, previously known as Poverty Flat, was virtually unsettled in 1872. The engineers laying out the railhead named the new community Redding, not for Major Pierson Barton Reading, the area's first white settler, but rather for Benjamin Barnard Redding, the general land agent for the Central Pacific Railroad. Merchants from the town of Shasta realized that the new town would soon become Shasta County's largest community.

By 1887, Redding's influence had grown to the point where the city's residents wrested the county seat away from Old Shasta. The town continued to grow and its regional influence extended outward to the limits of the county and beyond. Electricity and telephones became common throughout the city through the 1890s.

During this time and into the 20th century, new mining communities sprouted up north and east of Redding. Copper deposits were in abundance and out-of-town money poured into Shasta County to build huge smelters and spur railroad tracks. Complete towns were erected and grew to a population of several thousand. When the copper boom ended in the 1920s, many of these towns died. The closing down of the smelters was part of a general economic decline that affected the entire county, including Redding, and lasted for two decades.

This view looks north along Redding's Market Street in 1910. The Women's Improvement Club paid for the cement sidewalks and pedestrian crossings at busy intersections. Street lighting was provided by arc lights suspended overhead. Speed limit for autos was restricted to eight miles per hour.

Pierson B. Reading, the first non-native of Shasta County, was born in New Jersey in 1816 and worked for John Sutter as a clerk and trapper. In 1844, Reading became a naturalized Mexican citizen to fulfill a condition to get a land grant for Rancho Buena Ventura. When the Mexican government threatened to expel American settlers from California, he participated in the Bear Flag Revolt. Reading died in 1868.

Born in Canada in 1824, Benjamin Barnard Redding was the land agent for the Central Pacific Railroad from 1864 until his death in 1882. The railroad, needing a temporary railhead site, laid out the town and named it Redding. In 1874 local residents preferred to honor the first settler, P.B. Reading. After a bill was passed to change the name to Reading, the railroad and U.S. Post Office refused the change and another bill had to be passed to change the name back to Redding.

Chauncey Carroll Bush (1831–1907) arrived in Shasta in 1851 and worked as a mule packer. He was elected county judge in 1861. He was the first Redding merchant, the first Redding mayor, the first Redding fire chief, the first Redding postmaster, and the first chairman of the board of trustees.

The Bush House was built in Redding on the northwest corner of Sacramento and Market Streets when the railroad arrived in 1872. The Redding Hotel now stands in its place.

A Central Pacific locomotive is pictured here in front of the Depot Hotel in 1880. The gold-based economy of Old Shasta was declining and could not generate sufficient revenue to justify the cost of routing the railroad through the hilly countryside. Instead, the Central Pacific Railroad built its railhead in present-day Redding, which was situated on the last level piece of land before entering the Sacramento River Canyon.

This view shows Sacramento Valley & Eastern Engine #1. Railroad tracks extended from the Southern Pacific station of Pit to Copper City and Bully Hill.

Railroad hotels, such as the Redding Depot Hotel, seen here c. 1880, had restaurants and bars for passengers' convenience since there were no dining cars on trains at that time. Meal stops were usually 20 minutes in duration.

Pictured here is Daniel F. Adams City Livery Stable on Placer Street near the railroad. Harry Glover was Adams's blacksmith and also boarded with the family. Glover later had his own shop, which made the transition to automotive transport.

Four men, three of them county supervisors, are seen at a dedication event for Free Bridge, which was built in the early 1880s. The structure, later known as the Highway 44 Bridge, was washed away in a March 1907 storm. The bridge was replaced by a steel and concrete span that was put into use in March 1908.

In this *c.* 1870 photograph are, from left to right, Frank W. Smith, G.B. Graves, I.D. Standford, and R.B. Graves with two sacks containing $42,000 in gold on the table.

On July 23, 1892, brothers Charles and John Ruggles were lynched in Redding after having robbed the Weaverville-to-Redding stage on May 14 of that same year. A guard was killed and the driver injured in the attack. The brothers were taken to jail, where local women brought them treats and offers of marriage, prompting the jealous local men to organize the brothers' hanging.

This c. 1875 gathering of public officials includes the following individuals, from left to right: (front row) two unidentified men, Eliza Welsh, two unidentified men, Bill Jackson, and George Albro; (middle row) Judge Aaron Bell (middle, with long white beard); and (back row) W.O. Blodgett, Albert F. Ross, unidentified, T.B. Smith, Bill Hopping, and unidentified.

The Presbyterian Church was built in 1881 on the corner of Butte and Pine Streets. A 245-pound bell was given to the church by B.B. Redding in March 1881, and a Sunday school room was added in 1898. The "handsome" cement steps replaced wooden ones in 1908 as a "monument of stone" in honor of Judge C.C. Bush.

A group of young women await their baptism on the Sacramento River.

Pictured here c. 1903 is the Lorenz Hotel on the left and the Redding Water Company on the right. The Redding Water Company was the first to furnish hydroelectric power to the city. The water system was installed in 1885.

Built in 1903 for $10,000, Redding's Carnegie Library was located between the Lorenz Hotel and the railroad tracks. The librarian was paid $30 a month to perform library and janitorial work. Five hundred books were donated by the public. In 1965 the library was demolished and the bricks used on the outside walls of the Redding police department building.

Louis V. "Toots" Wolf was the proprietor of a Redding blacksmith shop, pictured here c. 1900. After he retired, Toots was a frequent "star" at local talent shows.

The valiant volunteers of Reliance Hook and Ladder Co. No. 1 look ready for action with their axes and leather belts in this photograph taken around 1900. The first firefighting group, formed in 1879, consisted of volunteers from among the business and professional leaders in the community. Three separate fire companies formed in 1896. To pay for parade uniforms, the organizations held a firemen's ball, which netted $26.70.

In this photograph of Civil War veterans, those from the South are pictured on the left, while those from the North are on the right. In the summer of 1861, a company of 86 local men were formed. To prevent capture of the mines, they helped to safeguard the southern border of California from invasion by Texas troops.

Redding's Armory Hall, pictured here c. 1910, was situated on the corner of Butte and East Streets. The scene of many community events, including balls, plays, and prize fights, the hall was destroyed on January 10, 1915, in a fire that also caused the explosion of 4,000 rounds of National Guard ammunition.

A steamroller grades and improves the streets of Redding in this c. 1910 photograph. The picture was taken at Tehama and Market Streets, in the area that is now the Mall in downtown Redding.

Eva Young poses in an early advertisement for her father's business—James Young Hardware—on Market Street.

Eda Bush photographs her friend Gertrude Glaszeen McNair, c. 1900. Eda was born in Shasta and was four years old when she moved with her family to Redding, where her father, Chauncey Carroll Bush, was operating a store in 1872. C.C. Bush built the first house in Redding for his family.

Elotia Chauncey Craddock sits on the porch of the John Craddock home in Redding in this c. 1900 photograph. Born in Aurora, Illinois, in 1842, she arrived with her family in Shasta County in 1854. She married veteran stage driver John Craddock.

This 1899 photograph of the Shasta Union High School girls' basketball team includes, from the back row, left to right, Etta Dennis, teacher Mrs. Ferguson, Mabel Lowdon, Linnie Isaacs, Edith Ashcraft, Clara Dean, and Jessie Rutherford.

This unidentified woman is ready to hitch up her two mules.

During World War I, Bertha Mullen provided Chester with timely subject matter. Here, she is dressed in her Red Cross nurse's uniform knitting socks for the soldiers. The flag and some of Chester's photographs are displayed on the shelf.

Built by Mr. and Mrs. Groves in 1887, the Del Monte Hotel and its beautiful gardens occupied the corner of Court and Placer Streets. The Groves' well water served not only this property but the business center of Redding. Pictured here are maids in front of the hotel.

Many Redding residents were taught by teachers Mona Wilder (1899–1981), left, and Delia Wilder (1894–1963), who are pictured here *c.* 1910. Their pet deer was named Trixie.

This hunting party consists of, from left to right, Martin Clifford, Dean Null, Allie Ligget, and Sadie Martin. The group is bringing home a pair of deer in matching sizes in this 1898 photograph.

The tikes on trikes in this c. 1910 photograph taken at the Bush home on Liberty and Butte Streets are, from left to right, Alan Shirek, George Bush, and Rolfe Shirek.

Albert Wright (left) and his brother James are out for a ride with three unknown ladies in the early 1900s. James opened a bicycle and machine shop in Redding in 1908.

The Wells Fargo & Company building, seen here c. 1910, served Wells Fargo, the Southern Pacific, and its subsidiary, Pacific Motor Trucking, since it was constructed in 1885.

The interior of the Wells Fargo & Company office is shown in this c. 1900 photograph. Expanding along with the population of California following the Gold Rush, by the turn of the 20th century, Wells Fargo was a major presence in many towns with its banking and express delivery services.

This is an early 1900s photograph of 100 tons of plate ice in the storeroom of Joe Hoefer's Salem Beer Depot. Hoefer Brewery was located on the corner of Trinity and California Streets.

In this 1906 view of Hoefer Brewery, drivers Rudolph Friebel and Fritz Jaegel sit on the wagon. Standing, from left to right, are Otto Jaegel, Charles Friebel, two unidentified men, and a man named Schnitzer.

Six unidentified man stand in front of Nathan's Fruit Stand in this 1890s photograph. The men proudly exhibit the tools of their trades.

From left to right Elsie Clineschmidt, Otto Kern, Louis March, and Martin Nachreiner pose for this *c.* 1913 photograph in the Klukkert City Bakery. Located at 1532 Market Street in Redding, the bakery was owned by Ben Klukkert and Steve Coughlin.

An 1890s photograph of Market Street shows a dirt road and wooden sidewalks. The awnings were in place to protect the buildings and people from Redding's unbelievable heat. The Temple Hotel is visible on the far right.

Dr. George Grotefend, whose dental office was located over Eaton's Drug Store on Market Street in downtown Redding, retired in the early 1940s. Grotefend had interests in cattle and mining. His Washington Mine in French Gulch produced the last big gold strike in the area. Grotefend also created and left scholarship trust funds for students.

On July 3, 1909, a crowd of 2,000 people gathered for a three-day celebration of the "glorious Fourth" near Eureka Way and Court Street. Captain Moore, whose real name was James Louk Caufield, was to make three flights in his airship *America*. But the fireworks started early and tragically when his hydrogen-filled dirigible exploded.

The *America* was to ascend at an angle of 45 degrees and a height of 100 feet. Moore called to his half-brother A.M. Short to let go of the lines. Moore reportedly yelled out, "Here's to a successful fly or a trip to Hades!"

Shortly after liftoff, the 58-foot ship tipped, causing the propellers to slice into the ship's skin, which was made of oiled silk. The airship then exploded.

Turning over and over, the burning airship and its pilot fell 40 feet to the ground. Some spectators were injured by the blast and a 78-year-old man named Milton Mygatt was trampled by the crowd and badly injured. Both men were rushed to St. Caroline Hospital. Due to his burns, Moore died that night.

75

A group of Redding gentlemen gather near the entrance to the Eaton, Reynolds & Co. Drug Store in the 1400 block of Market Street. The store, which opened in the fall of 1881, had a remarkable innovation—a telephone—that was used to make night calls to the doctor.

Moore's Green Grocery, pictured c. 1912, was located on Market Street. William Moore stocked his stands with fresh fruits and vegetables from the Central Valley that were brought in by trains. He also purchased produce from local farmers.

T.J Houston was a coroner, undertaker, and sheriff. "He was a jolly good fellow and could be elected to anything."

The McCormick-Saeltzer Store, pictured c. 1905, was located on Market Street between Yuba and Placer Streets. This was the state's largest general store north of Sacramento. The department store sold farm equipment, hardware, groceries, ready-to-wear clothing, and furniture. The covered drays are two of the store's many delivery wagons, while the other carriages probably belonged to shoppers.

Joseph Bailey operated the ferry across the Sacramento River near the Diestelhorst Bridge and was a watchman for the McCormick-Saeltzer Company, as was his son Charles. Daughter Jennie Bailey lived in Redding all of her 93 years. "Jennie Bailey was the prettiest girl in Redding" but never married after the death of her fiancé. Her name appears on the register of the first school in Shasta County, and she worked as a janitor at the West Side Grammar School until it closed in 1937.

This *c.* 1925 image of the home of Luke McDonald on Butte Street also includes, from left to right, (front row) Catherine Eberhart, Stanley De Forest, Joyce McConnell, and Charlie "Bags" McConnell; (back row) Luke, Elize Simpson, Gilbert De Forest, Eala McConnell, and Meda De Forest.

The Shasta County recorder's office is shown in this 1898 photograph. Given the technology of the day, photo subjects normally had to remain still during long exposures so the photographer, William Wax, attempted to create an illusion of "work in progress" by pre-arranging his subjects to look busy with office work and having them hold their poses while the film was exposed.

The Shasta County Courthouse was finished in 1889 at a cost of $46,525. The Hall of Records stands on the left. The ladies of the Women's Improvement Club induced the supervisors to beautify the grounds, and the landscaping was performed by jail inmates. In the name of progress, both buildings have since been demolished.

Lou Pool (right), Redding's first paid fire chief, poses in his city hall office with Will "Pop" Smith, the chief of police, c. 1915.

Following a raid on an illegal still, Sheriff William W. Sublett and attorney Hiram Baker are shown with alcohol-producing equipment.

Justice of the Peace Francis Carr poses in front of Redding's city hall in this c. 1907 photograph. The building, erected in 1906, once housed a jail, the police department, a wedding chapel, the city council, and city offices.

Patriotic volunteers stand in front of the old city hall where they enlisted and prepared to leave for military service in 1917. George Diestelhorst, whose family's roots go back 100 years in Shasta County, is pictured at the far right. (Courtesy of Dave Scott.)

The Redding Tigers of 1915 include, from left to right, the following members: (front row) Russ Thompson, Mel Gammons, Gerald Vettles, and Claude White; (back row) Jack Gardner (manager), George Diestlehorst, Dutch Wining, Jim Holt, unidentified, Harver Reese, Gil DeForest, and unidentified.

Redding residents watch Lassen Peak erupt in this May 22, 1915 picture. The mushroom-shaped mass of smoke rose nearly seven miles above the crater, and the powerful blast of hot air snapped trees like matchsticks. The fire department rang the fire bell when Lassen erupted and people ran into the streets to watch.

The first airplane to land in Redding, a Curtis biplane, appeared at the 1909 air show on the fairgrounds at the north end of Court Street.

The members of the Dreamland Boys Band, c. 1913, pose in front of the Dreamland Theater, the first movie theater in Redding, on Butte Street. The Dreamland Boys got together every Tuesday and Saturday to play. The theater burned down in 1924.

The crowd cheers as Miss Cottonwood walks the runway during a beauty pageant held as part of a water carnival in this mid-1920s photograph. The festivities on the Sacramento River, near the south end of Diestelhorst Bridge, also included races and diving contests.

John Nielsen rides on the George Bradbury float during the 1925 water carnival on the Sacramento River near the Diestelhorst Bridge. "Ford leads them all."

A diver jumps from the Diestelhorst Bridge into the Sacramento River in Redding in this 1930 photograph. The higher the platform, the higher a diver's status. The elite were those who not only could dive off the bridge railing but who could also shimmy up the light pole and then make their leap.

At the Diestlehorst "auto camp," floating, white canvas tents were used as changing rooms.

Built in 1873, Little Pine Street School, located on Pine Street between Placer and Yuba Streets, was torn down in 1957. J.W. Brackett was the school's first teacher. In 1873, there were 101 children in the Canon House School District with an average daily attendance of 76.

The last day of the 1889–1890 school year at Shasta High School in Redding featured "senior sneak day." Among those taking part were Ethal Nasan, Jessie Dunn, Frank Johnson, Bert Smith, Will Jackson, Myra Giles, George Bush, Jessie Bell, Adolph Dobrowsky, Ed Reynolds, Clarence Mille, D.E. Cramm, John Kite, William Bergh, and Ethan Bostrickt.

Participants in Shasta and Trinity Counties Day pose for a photograph at the Panama-Pacific International Exposition, which was held in San Francisco on April 2, 1915.

Shasta County's exhibit at the 1915 California State Fair in Sacramento is accompanied by, from left to right, unidentified, Edith Souza, unidentified, and grocer A.F. Souza holding a sack of "Shasta's Best" flour.

87

This bootblack stand in front of McConnell's saloon on Yuba Street was photographed *c.* 1910. Customers read the *Police Gazette* while getting their shoes shined.

"Bags" McConnell operated a tobacco shop on the south side of Yuba Street in the Hoff Building. During Prohibition the saloon became a pool hall and soda fountain.

In existence from the 1880s to 1963, the Idanha Hotel was run by Katharine Lack Lean, who had a popular boarding house connected with it. She did all the work herself, washing the sheets and cleaning. Meals were 22¢ each.

Built in 1901 by Holt and Gregg Company, the Bank of Shasta County was located at 1459 Market Street. The bank failed in 1911 and was purchased by the Bank of Italy, which later became the Bank of America. Pictured here c. 1914, the building, the second oldest in Redding, is still intact.

A c. 1920 Sunday outing sees an unidentified family with their children on the sidewalks of Redding.

May Day is thought to have originated as a spring fertility festival in India or Egypt, but it was still a time for festivities, picnics, and fun during the early part of the century in Redding. This photograph depicts girls dancing around a Maypole, c. 1920.

Girls in middy outfits salute the Navy on this battleship float, c. 1908. They may have been celebrating the visit of the Great White Fleet to San Francisco that year.

Redding school children and their teacher excitedly wave flags as they celebrate a patriotic holiday, c. 1920.

These children enjoy a donkey and cart ride, c. 1892. The lad on the left in the military cap is Henry Clineschmidt II.

Rudolph and Harriette McMahon Saeltzer (front row, center) enjoy their evening wedding reception on December 28, 1905.

Located on the corner of Tehama and Oregon Streets, this three-story hospital was built in 1900. It offered state-of-the-art medical, surgical, and obstetric services.

The original St. Caroline Hospital and Training School was built in 1907 at Sacramento and Pine Streets in Redding, and its $25,000 cost was covered by Redding business owners. The hospital was named after the mother of Dr. Ferdinand Stabel, one of the hospital's founders. Fire destroyed the building in 1909 and this building was constructed on the same location in 1910. In 1944 the Sisters of Mercy—which operate Mercy Medical Center in Redding—bought the hospital.

The Lorenz family owned and operated the famous Red Hill placer mine at Junction City in Trinity County. Thousands of dollars in gold were taken from this mine, and it was this gold that built the Lorenz Hotel in Redding. After her husband's death, Susan Lorenz purchased a marshy piece of ground on Yuba Street and built her four-story brick hotel.

The Firth store was housed on the street floor of the 1888 Odd Fellows Building, which still stands in Redding's Downtown Mall. The International Order of Odd Fellows (IOOF) began in the county with the institution of Shasta Lodge #57 at Old Shasta on April 25, 1856.

Shasta County had several newspapers. In 1852 the *Shasta Courier* was founded in Old Shasta. The publication moved to Redding in 1905 and, over many years, merged with several other newspapers until 1942 when it became known as the *Record Searchlight*. Seen here is an early 1900s printing press.

The United States mail was once delivered by wagon, as this *c.* 1910 photograph shows.

World War I ended on the 11th hour of the 11th day of the 11th month of the year 1918. On this day, an Armistice Day parade was held. Notice that many people are wearing flu masks in this parade photograph. From 1918 to 1919, an epidemic spread from the Western front, killing an estimated 500,000 people in the United States.

On January, 23, 1920, General John J. Pershing hangs over the back rail of a caboose to shake the hand of four-year-old Richard B. Eaton, the son of a veteran who died during World War I.

This c. 1914 photograph shows Wright's Garage, and Redding's first fire engine is on the left in front of city hall on Market Street. Fire Chief Louis Poole appointed Jim Wright as driver of the first motorized fire truck in Redding. Jim could both drive and repair the truck since his garage was so convenient to the fire hall.

The battery shop, where the terms were strictly cash, was located in the 1300 block of Market Street. The store's owner Dean Briggs stands in the foreground of this c. 1920 image.

Redding residents celebrate the holiday season in the early 1930s around the city's Christmas tree at Market and Yuba Streets. Students were treated to a free movie at the Redding Theater, and Santa Claus passed out bags of candy, nuts, oranges, and apples.

Odd Fellows parade down Market Street in 1928. The building where the J.C. Penney Co. sign hangs is now the home of the Shasta Historical Society.

A man crosses snowy Yuba Street during a winter day in this c. 1920 photograph taken by Chester Mullen. The Lorenz Hotel is pictured on the right.

On the left of this 1920s view of Market Street looking south are the old city hall and its palm trees, the fire department, Wright's Garage, and Temple Hotel.

Chester Mullen (1886–1958) earned his living as a carpenter, but he is best remembered as a photographer. His hobby paid off when he was paid by insurance companies to photograph damaged cars. He also made portraits of firemen and was hired to take mug shots of jail inmates. He sold many of his photographs as postcards.

Hotuby Turner was the manager of this gas station on Market and Placer Streets. The business sold Standard Oil products, Atlas tires, and batteries, and would lubricate your automobile. Several station attendants would rush out to provide services that included checking oil and water levels, putting air in tires, washing windshields, taking out car trash, and thanking customers for coming in.

Telephone operators take a watermelon break in this c. 1910 view. The telephone company was located just north of the Paragon Hotel on California Street. The girl in front is Alice Cook.

The Redding Chamber of Commerce building stood on Yuba Street in Redding, next to the Carnegie Library. The chamber was first organized in 1910, with Dudley Saeltzer as its first president.

Boaters and swimmers enjoy the water in this c. 1912 photograph. Before there was a bridge and access to the swimming hole, good swimmers could brave the wheel ditch, which supplied the water that drove a giant wheel and powered Redding's first electrical system.

In 1890 Francis Smith built this enormous water wheel of the paddle type, which ran a generator and furnished power to the city of Redding. It was constructed at the site of the A.C.I.D. diversion dam.

The Cascade Theater, seen here in 1935, had a modernist theme reinforced in concrete. Across the front of the façade is a wide frieze; the gilded figures are symbolic of Northern California's resources.

Residents got their first view of the inside of the new Cascade Theatre in downtown Redding at its opening on August 9, 1935. In addition to the posh lobby with its gilt and murals, the theater featured the latest technology and was one of the few local businesses that had air conditioning.

On February 28, 1940, a raging Sacramento River isolated Redding. Shasta Dam was under construction, but had no control of the river. None of Redding's three bridges were usable: the flood washed out the north end of the new Market Street Bridge and the east approach to the Free Bridge, and both approaches to the Diestelhorst Bridge were under water.

This scene depicts partially submerged homes near the railroad trestle during the flood of 1940. People used the new railroad trestle as a footbridge between Redding and communities to the north. Before the Shasta Dam was built, the Sacramento River often caused flooding in the winter months.

# Five
# OTHER AREAS AND COMMUNITIES

The story of Shasta County is similar to the story of numerous counties in the American West. From the beginning of habitation, with the Native Americans and their ability to successfully thrive in this region, succeeding waves of settlers displayed ingenuity and a strong work ethic to better their lives and increase their opportunities. Certain events and people played a key role in the development of Shasta County and, for the most part, helped determine the kind of economic and social lifestyle that would become prevalent among rural and urban citizens.

The small farming center of Anderson grew due to its location on the main railroad line. Produce from surrounding farms and ranches found their way to processing stations in Anderson. From here fruits and vegetables were shipped to Sacramento and other points. Kennett, the site for a large copper smelter, grew, by 1915, to rival Redding in population.

Just like the spur lines of railroad tracks, the new highway, designated Highway 99, sprouted spur roads—mostly paved—that linked eastern communities like Millville, Palo Cedro, Bella Vista, Shingletown, Whitmore, Burney, and others to Redding.

This patriotic celebration was photographed at a dance hall near the Cassel school in eastern Shasta County in 1910. Those pictured include Paul Opdyke (left) and Nell, Ralph and Ethel Bidwell, Percy Opdyke, Lucy Reiger, Otto Bolling, Minnie Dungan, Otto Giessner, Harriet Bidwell, Sykes and Stella Brown, Perry Opdyke, Irene Bidwell, and Frankie and Ethel Reaves.

In this Logan family portrait are, from left to right, (front row) children Stella, Clay, Ernest, and Sadie; and (back row) parents Lillie and Richmond. Richmond Logan acquired land and a home on Cow Creek in Palo Cedro. Lumber trains rolled through the ranch property on the old Terry Lumber Co. Line. Richmond was a farmer, a sheepman, a cattleman, a crack shot, and an avid hunter. Richmond had two buttes, a mountain, a lake, and a bridge across Cow Creek in Palo Cedro named after him.

Born in Prussia, Carl Voss and his brother Theodore arrived in Shasta County in 1870 to mine. In 1877, Carl married Julia Rector, and by 1886 they had five children. Sadly, Julia died in 1886. Carl gave their five-month-old son to his brother and sister-in-law, but he raised the other four children by himself. Carl bought 120 acres from Central Pacific Railroad Company, raised stock, and farmed.

Allan Fletcher, pictured here in 1892, was the nephew of Frank Shiell who owned the Harrison Gulch Store.

Members of the Fletcher family are pictured here, c. 1915, on a wooden bridge in Harrison Gulch. From left to right are Lina, Kenneth, Mr. and Mrs. Fletcher, Allan, and an unidentified man.

In this c. 1886 view of Bass Ferry on the Pit River, George Silverthorn is the second on the left.

In the days before air conditioning and backyard pools, jumping into the Sacramento River was the easiest way to cool off. In this c. 1920 photograph, summer frolickers play at the Kennett Ferry, an area that would eventually be submerged under Lake Shasta when Shasta Dam was built.

The Fourth of July celebration at the Mammoth Mine began with dynamite going off at the camp. Other activities included games of all kinds, a rock-drilling contest, and a parade that ended up at the ball park at the top of the hill. Baseball teams from Anderson, Mammoth Mine, Montgomery Creek, Big Bend, Keswick, Igo, and Terry Mill were in attendance.

Guests of the Vollmers Ranch Resort play tennis in this c. 1915 photograph. The ranch, about 30 miles north of Redding, was a popular vacation destination until about 1945 and was also well known for its commercially-grown strawberries. The ranch was sold in 1967 to make room for Interstate 5.

The Frederick Meyer Ranch House in 1891 was located on Cow Creek in the Bella Vista area.

A *c.* 1915 rodeo is held at the rodeo grounds in Bella Vista. The community of Bella Vista (which means "beautiful view") was established by Shasta Lumber Company in 1888. It was a business center for Terry Lumber Company.

On July 15, 1915, the Liberty Bell, en route to the Panama-Pacific Exposition in San Francisco, stopped at the depot in the mining town of Kennett. The bell traveled over 10,000 miles on the trip, stopping in many towns and cities along the way.

The Empire Hotel in French Gulch came into existence in 1857 and was built by a Mr. Feeney. The town commonly known as "The Gulch" has the distinction of being the place of birth of the first male child born in Shasta County. He was C.F. Montgomery, born on April 24, 1851.

The Tower House hotel, built by Levi Tower at the junction of Weaverville and Yreka roads in 1852, was a popular stopover for many years until it was destroyed by fire in 1919. Many hotel employees are pictured on the front porch in this 1912 photograph.

The French Gulch Saloon, the lavish Empire Hotel bar located on Main Street in French Gulch, became a favorite spot during the heyday of the gold mines in Shasta County. In this *c.* 1900 photograph, these women were dressed for a special occasion.

A team of horses pulls a freight wagon across Clear Creek in this c. 1900 photograph. Around the turn of the century, pack trains were going out of service and trails were widened into wagon roads to better serve the back country. Many roads ran over high, rugged mountains, and it could take a month or more round-trip to supply the towns that sprang up along the routes.

This c. 1900 photograph shows horse and wagon activity along Main Street in French Gulch. With the coming of the railroad to Redding, wagon roads that led out of the new railhead city were more frequently traveled with freight wagons, stagecoaches, and buggy traffic.

Two women admire an Anderson-Cottonwood Irrigation District pump and flume on the east side of the Sacramento River near the old Freebridge in Redding. The district was organized in 1914, and the canal was completed in 1920 at a cost of $1.2 million. The mostly earthen canal extends from Redding 30 miles south to Tehama County, aided by a tunnel and several flumes and siphons.

This 1916 view shows the start of work on the Anderson-Cottonwood Irrigation District's diversion dam across the Sacramento River near the present-day Market Street Bridge in Redding. Across the river, cattle graze in what is now Caldwell Park. Menzel's barn is located in the north.

The Holt and Gregg brick plant in Anderson began operations in 1880. The company manufactured materials for nearly every brick building in this part of the state until it closed in 1918. The drying racks could hold 100,000 green bricks. The Lorenz Hotel was built of bricks from Holt and Gregg.

A May Day parade is held in Anderson on Center Street at the height of the town's prosperity as an agricultural community. The town was named by the California and Oregon Railroad in 1872 for Elias Anderson, owner of the American Ranch.

Susan Robinson Wilder sits on a horse in front of Wilder Blacksmith Shop in Ono in this 1888 photograph. Those pictured include Bill Wilder, Erb Robinson, and John C. Wilder. Igo was formerly called Eagle Creek.

Leslie E. Shoup (left), Ed Long (center), and Howard Marx stand on their horses on the Marx Ranch in Bald Hills near Ono in this 1910 photograph. Ono was once a thriving community of homes, saloons, and hotels.

The Bartell brothers, Robert and Sylvanus, are pictured here in the 1890s at their blacksmith shop in Cloverdale. A few years later, the brothers took over a blacksmith shop in Ono, where they met and married the Taylor sisters, Edith and Nettie.

First known as Piety Hill, the town of Igo was established in 1849 and named for the regular religious and political discussions held by its pious residents. It was located a quarter mile east of the present-day town of Igo. In 1866 all the residents, except those of Chinese descent, moved across Conger Gulch to the new town of Igo.

A Fourth of July celebration in 1890 is held at the Candy Store in Abraham Cunningham's apple orchard on Berry Creek between Shingletown and Manton.

This 1910 photograph shows a crew taking a break from a barn-raising project at the Pritchard ranch in Manton. The barn was built by Fred Bunn with the help of some friends. Bunn walked six miles one way to earn $1 a day for his labor on hand-hewn timbers, and it took him a year to complete the wood preparation.

Established as a California & Oregon Railroad flag station spur two miles south of Castella, the community of Conant was named for William Conant who mined for gold on the headwaters of Castle Creek. This photograph was taken in 1906.

This 1885 photograph shows the Castle Rock Station, which was the starting point of Lower Soda Springs and Pit River Toll Road.

Pictured along with fish caught in the streams around Viola are Lec Daily, Dide Morgan, Estelle Loomis, and her daughter Mae. This photograph was taken by B.F. Loomis around 1909. The Loomis family built a rock home for Mae, which still stands in Lassen Volcanic National Park.

Leland Gay (left) and Chester Mullen pose for this 1930s photograph with Lassen Peak in the background. The men faced a challenge as they considered their next move; one wonders how far they had to back the auto until they could turn around.

Fire crew members pose for a photograph on June 30, 1913, in front of District Four Fire Protection Force headquarters in Knob. Pictured, from left to right, are Shelby Ward, Harry Moore, Ivan Cuff Box, Reuben Preston Box, Ernest Duncan, and Bob Watson. The animals belonged to Bob Watson.

Coram was established in 1906 by the Balaklala Mine and Smelter Co. There was never a cent collected for property taxes because the many saloon licenses paid all the bills and salaries needed for the town. Pictured here is the McCormick–Saeltzer Store.

This photograph of Eva Wheelock Hoover Farnham was taken near Ritts Mill on Shingletown Ridge when she was about nine years old. Born on February 14, 1897, Wheelock was the fourth generation of her family to live in Shasta County. She attended Redding schools, graduated from Shasta County High School in 1915, and received her teaching credential from Chico State Normal School in 1917. During her early years, she supplemented her income by selling Dodge cars. Part of her sales technique was teaching prospective buyers how to drive. She died in 1971.

The school at Old Diggins, in the Walker Mine Road area, is pictured here in 1895 as teacher A.F. Souza stands with a switch and bell in hand. Souza also served as tax collector and treasurer for the City of Redding for many years. In those days, school grades ran from the first to the ninth.

Members of the Fitzpatrick family seen here are, from left to right, Asa, Thelma, and Bill Fitzpatrick at work in their blacksmith shop in Burney, c. 1910. The town of Burney was settled in 1858 by a trapper and emigrant guide named Samuel Burney.

Goose Valley School was located northwest of Burney. Pictured here are, from left to right, Lillie Hobson, Eva Haynes (Giessner), Johanna Haynes (Giessner), Etta Haynes (Hufford), Roy Mullen, Harold Hobson, teacher Mrs. Hobson, Birdie Haynes (Bidwell) in front of teacher, Oakley Fitzpatrick, Orie Grant, Josie Mullen (sister of photographer Chester Mullen), Pearl Haynes (Barnes), and Lela Grant (Rhoads).

Built in 1890, the brick home of Samuel T. Alexander still stands on Palm Avenue in Happy Valley. Alexander planted 135 acres of his land in olive trees. He died in 1905 about the time that his grove was beginning to produce.

Hop pickers gather in Whitmore in this 1904 photograph. Vines climbed up strings hung on wires in the spring; in the fall the hops were picked, dried in kilns on the ranch, baled, and hauled to Anderson. They were then shipped to the Horst Brewing Company in San Francisco for use in making beer.

Cutting peaches for drying on the Heaton ranch near Jelly's Ferry, c. 1905, are, from left to right, N.F. Heaton, Thuza Scott, Marie Scott (Kueny), Sybina Scott, Clifford Heaton, Mrs. N.F. Heaton, Christania Hawkison, Mary Baker, and Edna Courtz.

All buildings in this 1907 photograph of Main Street in Cottonwood were constructed by A.J. and P.D. Logan. The building on the left was where their traction engine was invented. The town of Cottonwood was named by John Fremont in 1846 for the many trees growing along the creek.

Eleanor Templeman, pictured here on a successful bear hunt at Squaw Creek Canyon, was the daughter of Robert Lee Reading and granddaughter of Pierson B. Reading. Her childhood was spent in Redding in a large house on the corner of Court and Gold Streets.

Delamar, pictured here c. 1915, was named for Captain J.R. DeLaMar, who built the smelter for the Bully Hill Mine in 1899. The town was known by three names: Delamar, Winthrop, and Bully Hill.

Born in Millville on May 7, 1906, Roy Farrell is seen here, c. 1928, at Farrell's summer cattle camp at Don Hunt meadows. Roy's father, Charles "Ed" Farrell, was born in Millville in 1876. Roy's grandmother, Margaret Jane Dalton, came west in 1850 by wagon train from Ohio to Shasta County. She was one of only seven white females in Shasta County. The Farrell family raised horses, cows, sheep, hogs, and turkeys. They rented the Lack place from Dan Hunt in 1922.

North Star Mill, the first flour mill in Millville, is pictured in 1890. In 1855, Drury D. Harrill hired George and Russell Farnum to build a water-powered grist mill close to the Stroud Ranch on Cow Creek. Herman F. Ross and Henry Wilkinson bought the flour mill in 1865 from Henry Anklin and Jim Keene.

The Pit River bridge was originally built in 1915 and was one of several concrete arches on what was then called the Pacific Highway. When the bridge was new and traffic was light, dances were held on the smooth concrete deck. The bridge was submerged when Lake Shasta was filled, but a new span across the Pit River was built in 1941. The bridge now spans Lake Shasta.

Women from the Johnstone, Bass, and Cross families tend to their cooking duties during a camping trip to the Cove, in the Pit River country west of Montgomery Creek, in this *c.* 1918 picture.